PAINTING
IN OILS

BY WILLIAM PALLUTH

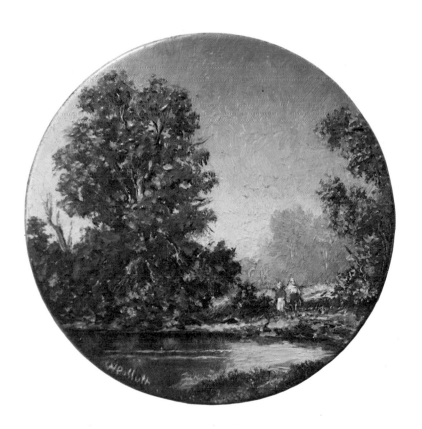

Walter Foster Publishing, Inc.
430 West Sixth Street, Tustin, CA 92680-9990

CONTENTS

To Carol

Introduction

The goal of the artist should be to capture on canvas the beauty of nature that is so often missed as we race through life. Landscape painting, more than any other form of art, approaches this goal.

For the professional artist, art is a way of leaving something behind for the world to enjoy for generations to come. For the Sunday painter, art is an escape into a magical world of creativity, creating something beautiful that was not there before, and is a way of getting a tremendous feeling of accomplishment that seldom comes from the day to day job. For the viewer and art buyer, art is an escape from the hurries and worries of today's fast society into another world; a world of memories, fantasy and beauty, and a needed rest for the weary soul. So you see, art is not really a luxury but a necessity for modern mankind.

This book is for the artist, the aspiring artist, and for just plain people who wish to be able to put their impressions of the world around them onto canvas. An effort has been made to show the various oil painting techniques and then demonstrate how they are used to produce oil paintings. Demonstration paintings begin with simple subjects and then progress to more complex ones and introduce new techniques with each demonstration.

The end purpose of this book is to provide anyone who wants to paint in oils with enough knowledge and practice in the various oil painting techniques so that they will be able to express themselves well in the medium. Eventually, with time and practice, they will develop their very own styles.

William Palluth

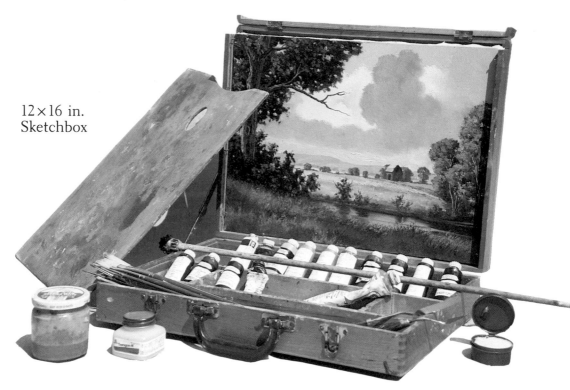

12×16 in.
Sketchbox

MATERIALS and EQUIPMENT

SKETCHBOX: A sketchbox is handy for organizing and carrying materials from place to place. The 12″×16″ box shown here is a good size because it will hold standard 12″×16″ panels or canvasses...just the right size for sketching outdoors. Also shown are a wooden palette, brushes, painting and palette knives, a mahl stick, and containers for turpentine, medium and hand cleaner. All of this should fit into the sketchbox for transportation.

OIL PAINTS: Buy only the better brands in large studio size tubes. Cheaper brands won't give you the rich colors you want no matter how hard you try. Better brands will actually cost less in the long run. This list of seventeen colors will give you just about any mixture you'll ever need.

TITANIUM WHITE CADMIUM RED LIGHT RAW SIENNA
SAP GREEN CADMIUM YELLOW LIGHT BURNT SIENNA
CERULEAN BLUE CADMIUM YELLOW DEEP RAW UMBER
COBALT BLUE CADMIUM ORANGE BURNT UMBER
ULTRAMARINE BLUE NAPLES YELLOW HUE IVORY BLACK
ALIZARIN CRIMSON YELLOW OCHRE

Many artists do not include green on their palettes. Instead, their greens are mixed by using various blues, blacks and yellows. I didn't use greens either until Sap Green became available. The addition of Sap Green to my palette has made many color mixtures much easier. It's also the direct opposite of Cadmium Red Light on the color wheel, and is therefore useful for shading and neutralizing that color.

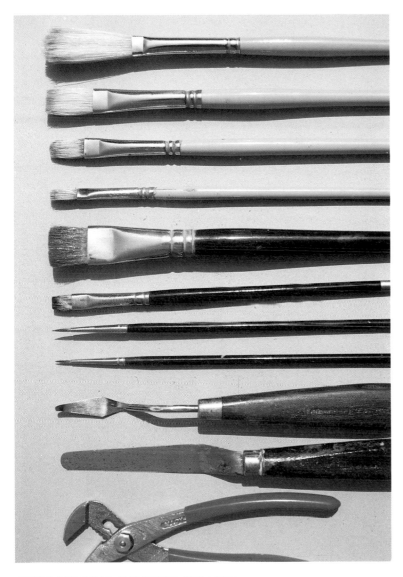

No. 5 Long Filbert Bristle brush for close grass & weeds

No. 8 Flat Bristle brush for lay-in of large masses

No. 4 Flat Bristle brush for smaller areas

No. 2 Flat Bristle brush for details

No. 20 Bright Sable brush for blending and softening edges

No. 8 Bright Sable brush for barn siding and details

No. 3 Round Sable brush for details and signatures

No. 1 Round Sable brush for smaller details, miniatures

One Inch Painting Knife for rocks, bark of trees, etc.

Palette Knife for scraping the painting or palette, and for mixing colors

Small Pliers for opening stubborn tubes of oil paint

THE TOOLS OF THE TRADE

BRUSHES: The brushes shown above are sufficient for most needs. As you progress, you'll find some others you'll want to try. Most oil painting is done with bristle brushes, and the ones I like are the flat bristles. They have longer bristles than the brights and can be used with a softer touch—the secret of brighter colors. The large sable brush is used for blending colors and softening edges, such as for soft clouds and reflections in water. (Almost any soft brush will do.) As with oil paints, buy the best brands.

PALETTE: Wooden palettes should be rubbed with linseed oil before using. If you don't like cleaning the palette, disposable paper palettes are available.

MEDIUM: I use Copal Painting Medium, which is fast drying and good for glazing. Alkyd mediums are even quicker drying and leave less of a gloss finish.

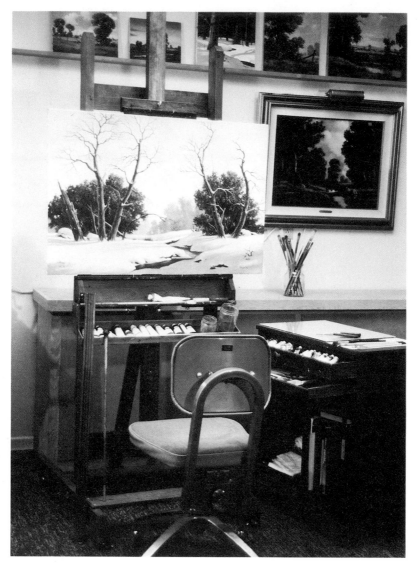

STUDIO ARRANGEMENT

This is my studio setup, looking a little more respectable than usual. The easel is situated under a milkglass skylight which provides all the light I need on sunny or cloudy bright days. At night I revert to the overhead flourescent lamps. It pays to have everything as handy as possible to make the task easier, so I've added an extra shelf under the easel tray to hold tubes of oil paint in the same order I use on my palette. The taboret to the right has drawers for seldom used oil colors and brushes and the palette on top is a piece of clear plate glass placed over a sheet of grey paper. Paintings in process can be placed on the wall shelf while drying. Out of the picture to the left is a drawing table for studying, sketching and holding vast piles of sketches, slides, books, half empty coffee cups, and a few things that even I don't recognize.

An artist doesn't have to have a studio like this to do fine work. It merely makes it easier. But it is necessary to have at least a corner to call your own where you can leave things out, ready at a moment's notice to go to work.

Oil Painting TECHNIQUES...

Oil paint is a very versatile medium. Anyone who paints in oils would do well to explore as many different techniques as possible. Some of them are bound to come in handy at times. Many of the techniques are shown on these three pages and more are demonstrated throughout the rest of the book...enough, I hope, to whet your appetite for trying some of them.

Don't worry about developing a technique of your own. It will come in time. Just keep studying and trying different techniques and palettes until you find a combination you're really comfortable with. Eventually a style of your own will emerge and people will begin to recognize your work.

IMPROPER USE OF OIL PAINTS...Here the paint has been applied too thinly and spread too far. This method is useful only for underpainting.

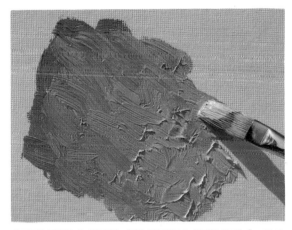

GET FULL USE OF THE MEDIUM...Oil paints are best applied at the consistency of soft butter, thick enough to cover well but not leave canvas texture exposed.

WET IN WET...Oils are especially suitable for painting wet in wet (a wet layer over a still wet layer). It requires a soft touch and thick paint (see pg. 9).

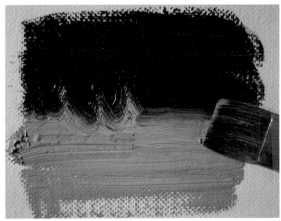

BLENDING...To blend different values or colors, lay them side by side, intermix them by running brush back and forth between them, and smooth with clean brush.

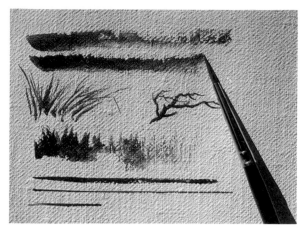

SMALL DETAILS...A small round sable brush is used for details and often for sketching in the outline drawing. Try using one both flat and perpendicular to the canvas.

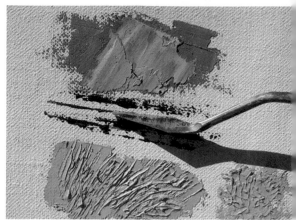

PAINTING KNIFE...Here are some strokes using a painting knife; from top to bottom, using knife flat, using the edge of the knife, and using the tip of the knife.

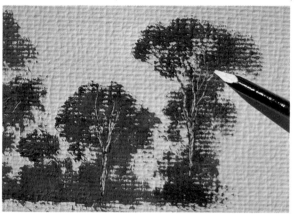

SCRAPING OUT...Use sharpened end of brush to scrape out blades of grass, branches and twigs, trunks of far trees, and texture in bark. Paint layer must still be wet.

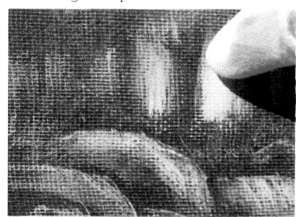

WIPING OUT...Starting with thinly applied paint, highlighted portions are wiped out with a clean rag wound on a finger or a brush handle. Used often in portraits.

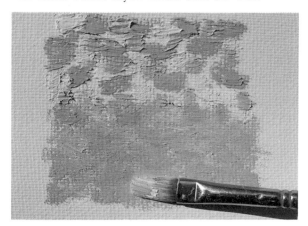

IMPRESSIONIST...Form or color masses are built up with short broken strokes or dabs of thick paint applied with brush or knife, then blended only slightly.

SCUMBLING...A thick layer of light tones can be loosely applied over a thin layer of dark tones by using a light touch and the flat side of a fully loaded brush.

PROPER USE OF FLAT BRISTLE BRUSH

Common Technique...

Many artists hold their flat bristles as if they were drawing with a pencil. This causes them to brush too deeply and spread the paint too thin.

Common Result...

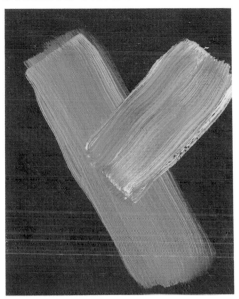

The result is usually dull or muddy colors as the brush digs up the darker layer underneath. (The brush also wears much faster!)

Better Technique...

Hold the brush this way, (flat to the canvas) and use it fully loaded with thicker paint and apply with a very light touch.

Better Result...

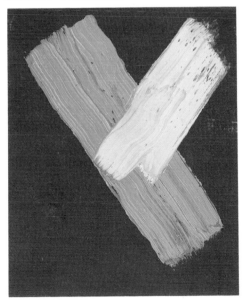

The result should be cleaner, richer and brighter colors. (So much for so little!) Try this experiment and see for yourself.

SO TRY IT! THINK FLAT AND THINK THICK!

MIXING COLORS...

SKY
BLUE

1. Always start very light color mixtures with White. If it's started with a dark color, it takes tons of White to lighten it.

2. Then carefully add the dominant color until the approximate value is obtained. Here I've used Cobalt Blue.

SUMMER
LEAVES

1. Start darker mixtures with the dominant color rather than White. Here I've started with Sap Green.

2. Add Cadmium Red Light (the complement of Sap Green) to darken for leaves in the shade.

AUTUMN
LEAVES

1. First establish the hue (color) with Alizarin Crimson and Cadmium Yellow Deep.

2. Add Sap Green and more Crimson for darker values in the shadows.

3. Next add Yellow Ochre until the mixture is close to the desired hue. Some artists stop at this stage.

4. Last, add just a touch of Crimson to tone the mixture down. (Lower its intensity.)

3. Add White and Naples Yellow to No. 1 to lighten for leaves in the sunlight.

4. Here's what the lighter value looks like over the darker value. (A mixture of the two would make a good midtone.)

3. Add White and more Yellow to No. 1 to lighten values for sunlit leaves.

4. Here are all three tones together; dark first, then midtones over dark, and finally the lights.

11

AUTUMN COLOR: Demonstration

This painting contains just sky, trees, and grass plus a section of fence. That should be enough to introduce us to landscape painting. On the following pages you'll find step paintings showing progressive stages as I proceed. There are also detailed steps for painting the sky, the foreground tree and the grass. But first, a word about trees.

TREES...

Trees are the most common and probably the most obvious elements in landscape paintings. They are also possibly the greatest challenge to the landscape artist. Every landscape painter should have a handy pocket guide to identify trees on any sketching or picture-taking trip. The guide should also tell which part of the country each tree grows in. (You wouldn't want to paint an Oak tree on a tropical island or a California Laurel in Maine, would you?)

Most trees can be identified by their leaves, but the most important characteristics for artists to know are the overall silhouettes and the way the trunks and branches are formed on certain families of trees. In fact, many trees can be identified by their silhouettes alone, which the artist must make both interesting and realistic.

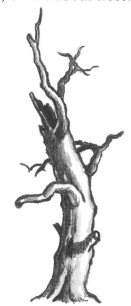

Make them three dimensional

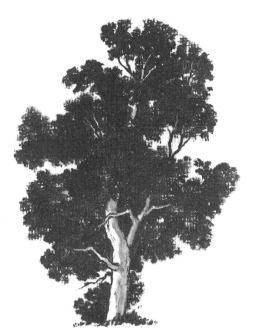

Before starting to sketch a tree, first analyze it. What does the overall mass (silhouette) look like? Is it an interesting shape? Is the trunk straight, curved, or crooked? Can it be made more interesting by emphasizing the curves or bends? How about leaving a bare branch here and there? Don't forget to capture its characteristic shading, and to keep the sky holes random in size and spacing.

Becoming adept at painting trees requires some study and practice. But the results are worth it because well executed trees can be the most interesting and beautiful elements in a landscape painting.

The silhouette is important

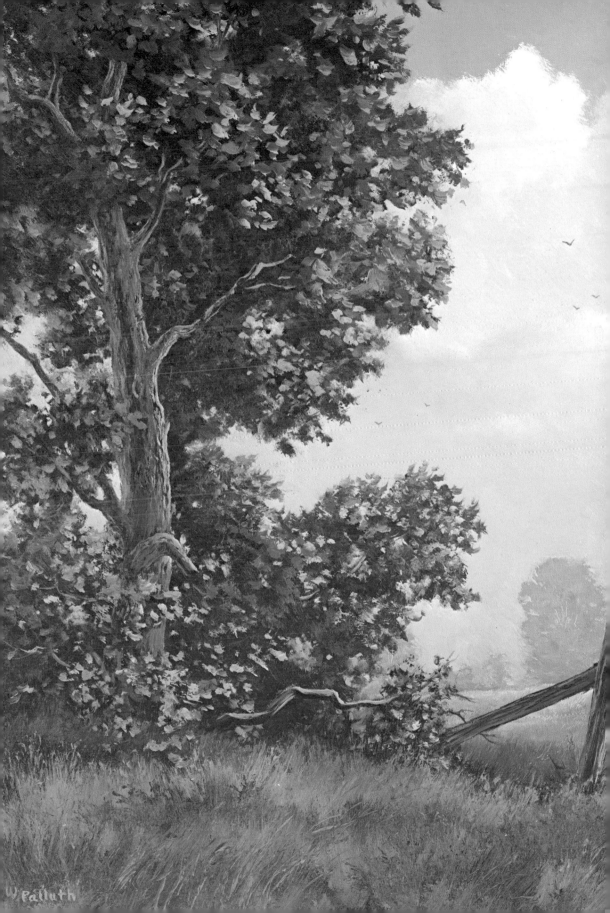

Every good picture needs to start with a good sketch.

For quick sketches outdoors I often start right out sketching with soft charcoal and then wipe off the excess with a soft brush before starting to paint over it.

Studio paintings are usually the result of many small pencil sketches. The best of these are projected onto canvas by using an opaque projector. Pictures with considerable detail are projected onto tracing paper and very carefully drawn until the details satisfy me. Then the drawing is transferred to the canvas using transfer or graphite paper.

STAGE 1—SKETCH

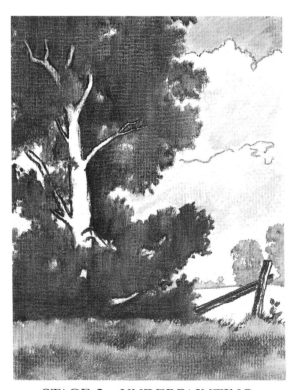

My next step is underpainting the entire picture with a thin wash of Raw Umber and turpentine, trying to approximate the correct values. I lighten some values by wiping with a clean rag or facial tissue. The tree foliage is done by laying a flat bristle brush almost flat on the canvas and just lightly moving it around. Around the edges I am more deliberate, twisting and turning the brush to get a random leafy pattern.

The finished underpainting should resemble a sepia tone photo and gives me a good idea at this early stage what the finished painting should look like. NOW I'M READY FOR COLOR.

STAGE 2—UNDERPAINTING

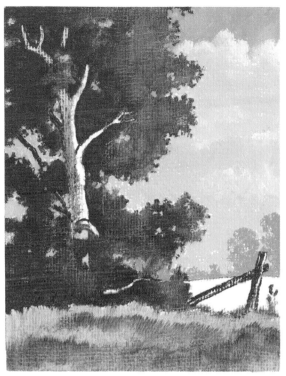

When I did the underpainting I didn't have to worry about color. I was only concerned about the composition and values. Now I'll add color and just try to match the values I've already established.

In each painting I always start at the top with the sky and work my way down toward the foreground. The sky is usually the main source of light and should set the overall mood and value range for the rest of the scene. The first step is mixing a pool of colors to use while painting. The mixing of the colors and steps to painting the sky are shown on the next two pages.

STAGE 3—SKY & FAR TREES

The far trees are painted next with darks of Cobalt Blue, Raw Umber, Crimson and White. Then I add some lighter values of Ochre, Crimson and White, blending with the undertone so there won't be too much contrast. The golden field is painted with a loose mixture of Burnt Sienna, Naples Yellow and White, plus some darker accents with Sap Green added in.

The painting of the close tree is covered in detail on pages 18 and 19. I've left much of the darks and middle tones showing here to show how it's painted from dark to light.

STAGE 5— GRASS & WEEDS

Pages 20 and 21 show the painting of the foreground grass and weeds. The colors used for the tree trunk can also be used for the fence posts.

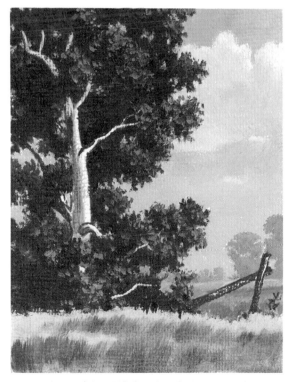

STAGE 4— FOREGROUND TREE

USING GRADED POOLS OF COLOR...

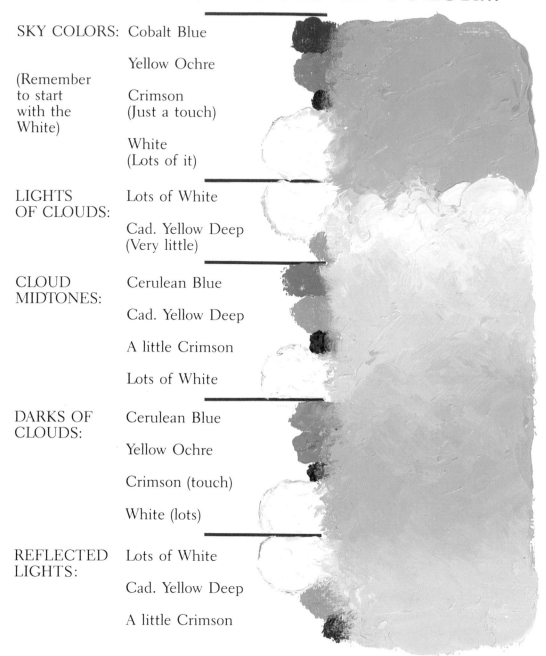

SKY COLORS: Cobalt Blue

Yellow Ochre

(Remember
to start
with the
White)

Crimson
(Just a touch)

White
(Lots of it)

LIGHTS
OF CLOUDS:

Lots of White

Cad. Yellow Deep
(Very little)

CLOUD
MIDTONES:

Cerulean Blue

Cad. Yellow Deep

A little Crimson

Lots of White

DARKS OF
CLOUDS:

Cerulean Blue

Yellow Ochre

Crimson (touch)

White (lots)

REFLECTED
LIGHTS:

Lots of White

Cad. Yellow Deep

A little Crimson

I start by mixing a large pile of each color needed for the sky and clouds, and then blend these piles together into one graded pool of color. The sky color should gradually change from the darkest to the lightest tones, and the same with the cloud colors. Then I merely pick up colors from this source pool as I paint. After all, painting is merely picking up the right color and putting it in the right place, isn't it? So if we have all the colors mixed, the job is half done. The next step is to use these color mixtures to paint the sky as shown on the next page. If this method of painting is all you learn from this book, you may already have received your money's worth.

16

PAINTING THE SKY...

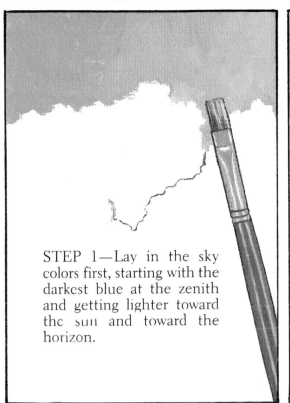

STEP 1—Lay in the sky colors first, starting with the darkest blue at the zenith and getting lighter toward the sun and toward the horizon.

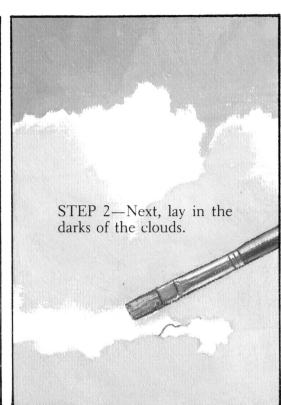

STEP 2—Next, lay in the darks of the clouds.

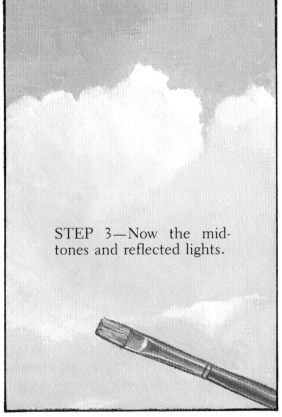

STEP 3—Now the mid-tones and reflected lights.

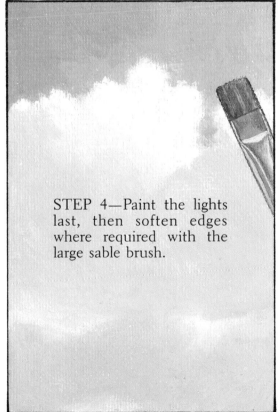

STEP 4—Paint the lights last, then soften edges where required with the large sable brush.

PAINTING TREE FOLIAGE...

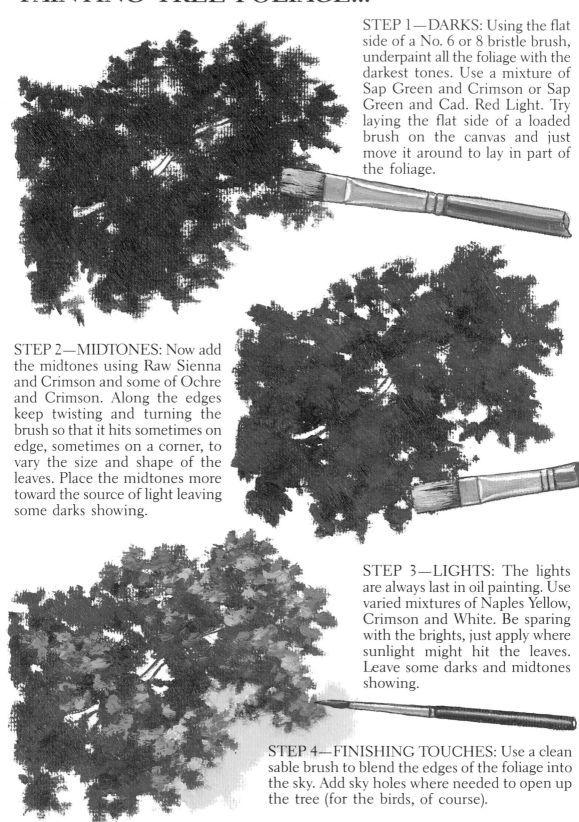

STEP 1—DARKS: Using the flat side of a No. 6 or 8 bristle brush, underpaint all the foliage with the darkest tones. Use a mixture of Sap Green and Crimson or Sap Green and Cad. Red Light. Try laying the flat side of a loaded brush on the canvas and just move it around to lay in part of the foliage.

STEP 2—MIDTONES: Now add the midtones using Raw Sienna and Crimson and some of Ochre and Crimson. Along the edges keep twisting and turning the brush so that it hits sometimes on edge, sometimes on a corner, to vary the size and shape of the leaves. Place the midtones more toward the source of light leaving some darks showing.

STEP 3—LIGHTS: The lights are always last in oil painting. Use varied mixtures of Naples Yellow, Crimson and White. Be sparing with the brights, just apply where sunlight might hit the leaves. Leave some darks and midtones showing.

STEP 4—FINISHING TOUCHES: Use a clean sable brush to blend the edges of the foliage into the sky. Add sky holes where needed to open up the tree (for the birds, of course).

GIVING FORM TO TRUNK AND LIMBS...

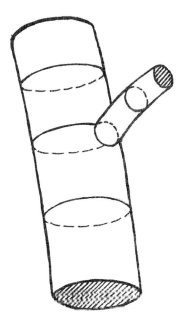

Trunks and limbs are round like cylinders. The artist needs to show this roundness.

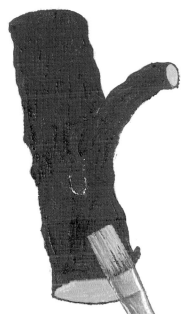

STEP 1—DARKS: First paint trunk and limbs with Raw Umber and Cobalt Blue.

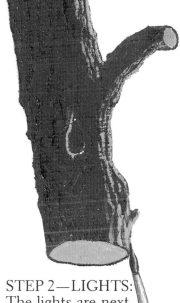

STEP 2—LIGHTS: The lights are next. Use Raw Sienna and White.

Form is shown by proper use of values.

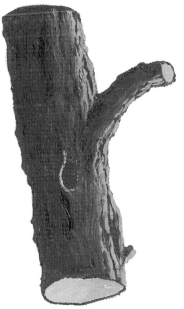

STEP 3—MIDTONES: Now blend the darks and lights together using midtones of Raw Sienna, Burnt Sienna & White.

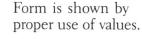

STEP 4—REFLECTED LIGHTS: Use Cobalt Blue, Raw Umber and White to paint in the reflected light from the sky.

Normally in oils we start with the darks, move next to the midtones, and finish with the lights. But here I found it easier to do the darks, then the lights, and then blend the two with the midtones. The important thing to remember is not to put darks over lights until the lights are thoroughly dry.

A TECHNIQUE
FOR GRASS & WEEDS...

For doing grass and tall weeds, I like to use a Long Bristle Filbert Brush, No. 5. To obtain the right affect, the bristles should be almost two inches long. I jab the brush into the canvas at a slight upward angle, as shown in this photo, and let the bristles flip upward. This gives me lots of individual weeds and even seed pods on some of them. The paint must be thick and the brush dry. This stroke takes lots of practice, but it's worth it.

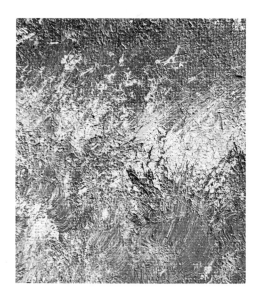

Cleaning the brush every time I change from dark to light colors and back gets to be a little old, so I use two brushes; one for the lights and one for the darks. This way I have no trouble keeping the brushes dry.

Try doing some weeds like this on a piece of scrap paper or canvas. You may be surprised with the results. You might even enjoy it!

This is what the first set of strokes should look like. I started with the darker tones, but it depends on whether there are dark or light tones behind them.

The second set of strokes should contrast with the first so that some individual weeds will stand out. Here I placed the midtones next, and then some lights.

Next I put in some more darks followed with more lights. See how the changes in values make the weeds stand out? Be careful not to get rows of darks and lights clear across the canvas. Learn to think in terms of areas of darks and lights.

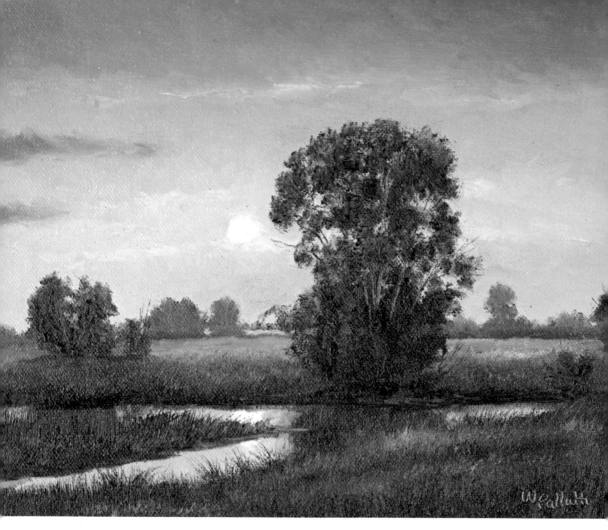

8×10 in. (20×25 cm.)

EVENTIDE: Demonstration

This painting was made near Ann Arbor, Michigan after a summer rain storm. The water is runoff from the storm that settled in a low spot in the field. The storm was still breaking up when the sun began to set. Being an artist, I had to do more than just watch it. I took pictures to capture the moment in color. The next day I made sketches of the scene. Back at the studio I created this picture from the sketches, the slides, and my memory of the moment.

One note of interest. This is actually a view looking north. To add interest, I used "artist's license" and merely swung the sun around to the north so it would reflect into the water. Simple, isn't it?...don't you photographers wish you could do that?

STAGE 1 – SKETCH

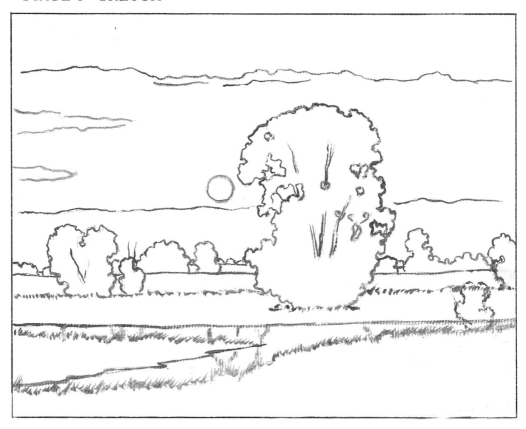

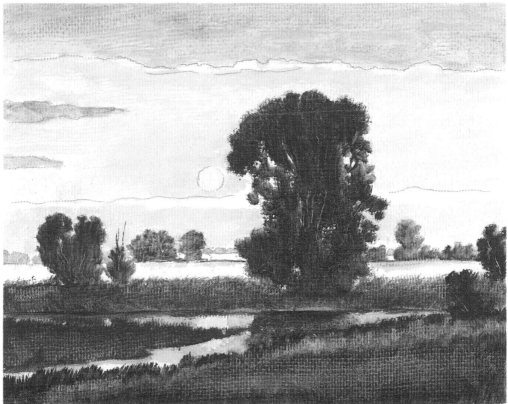

STAGE 2 – UNDERPAINTING

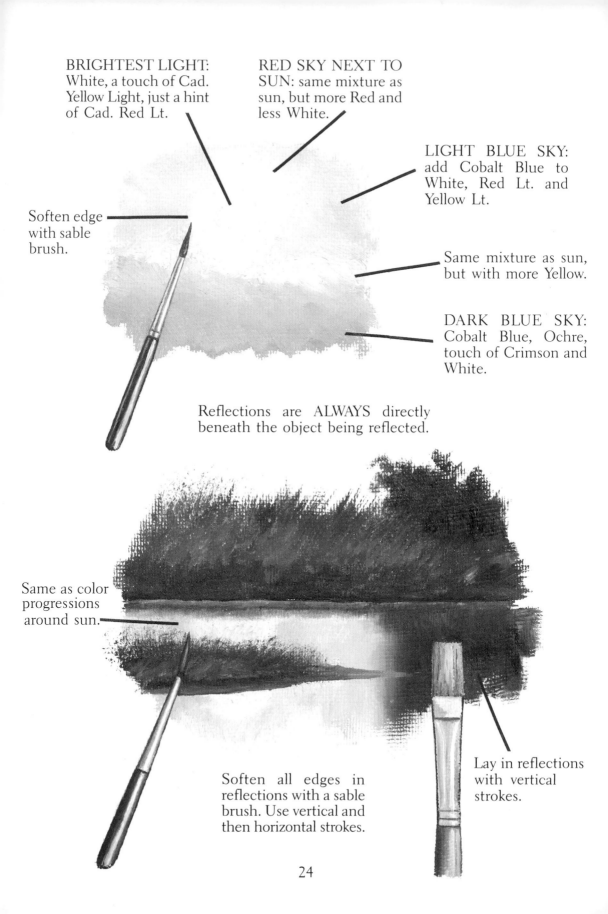

BRIGHTEST LIGHT: White, a touch of Cad. Yellow Light, just a hint of Cad. Red Lt.

RED SKY NEXT TO SUN: same mixture as sun, but more Red and less White.

LIGHT BLUE SKY: add Cobalt Blue to White, Red Lt. and Yellow Lt.

Soften edge with sable brush.

Same mixture as sun, but with more Yellow.

DARK BLUE SKY: Cobalt Blue, Ochre, touch of Crimson and White.

Reflections are ALWAYS directly beneath the object being reflected.

Same as color progressions around sun.

Soften all edges in reflections with a sable brush. Use vertical and then horizontal strokes.

Lay in reflections with vertical strokes.

24

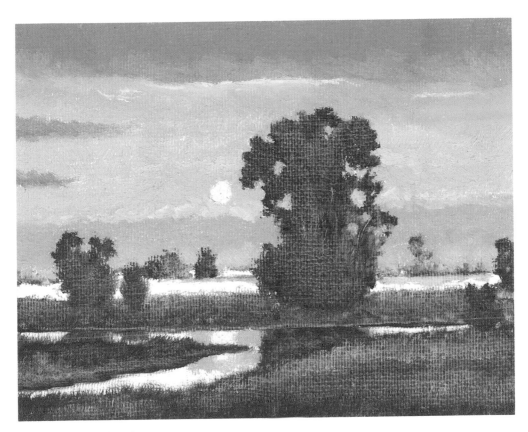

STAGE 3—SKY

STAGE 1—SKETCH

The first painting was just trees, sky and grass. In this one we add water and a setting sun. The sketch is done in Raw Umber and turpentine.

STAGE 2—UNDERPAINTING (VALUE WASH)

Again, I try to approximate the values with a thinly applied wash of Raw Umber and turpentine. I can't overemphasize the importance of this step. It's often hard to get the right value and right color simultaneously. It makes it so much easier to obtain correct values in a monochrome first, and then simply to match these values when we add color. Try it yourself and see.

STAGE 3—SKY

I put in the bright sun first with rather thick paint, and then start at the top of the painting and work my way down toward the horizon. Since the colors are already mixed, this is a good time to put in the reflections. The sky and reflections are shown in detail on page 24. The color mixtures are shown there also.

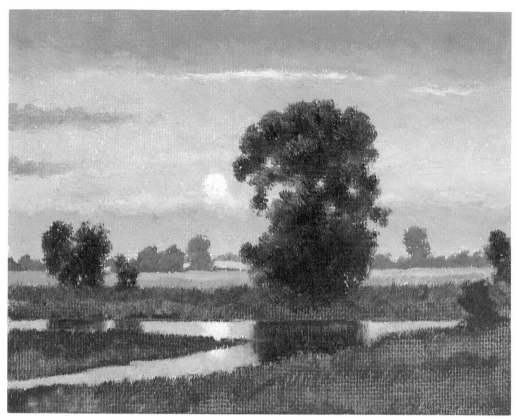

STAGE 4—FAR TREES & FIELDS

For the background trees I just add a touch of Sap Green to the color of the upper sky. The mixture is now Cobalt Blue, Ochre, Crimson, White and Sap Green. The far fields are Sap Green, Naples Yellow, Crimson and White. Working my way forward, I lay in the dark tones of the close trees with a mixture of Raw Umber, Crimson and Sap Green. The closer trees reflect in the water so I lay in the dark of the reflections at this time.

STAGE 5—FOREGROUND & FINISHING TOUCHES

The midtone for the closer trees is a mixture of Sap Green, a little Naples Yellow, Crimson and White. No bright tones are needed because of the back lighting. The limbs of the trees are scraped in with the sharp end of a brush handle and a little of the light blue sky color is added in places.

The dark tones in the foreground grass are Raw Umber, Crimson and Sap Green. The midtones are Ochre, Crimson and Sap Green. The lights are Naples Yellow, Crimson, Sap Green and White. In places I add touches of Cadmium Orange for color. In a painting with many dark tones like this one, I feel an extra effort must be made to keep the colors clean and rich.

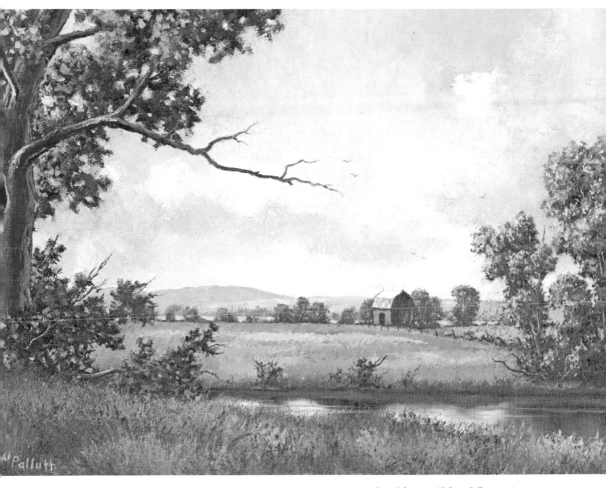

9×12 in. (23×35 cm.)

WARD'S FARM: Demonstration

The encroachment of urban civilization on the countryside is fast taking away the restful country scenery once found within an easy Sunday drive from where we live. However, many parts of the country are still blessed with small picturesque farms complete with winding streams, reflecting ponds, lush trees, and interesting old barns. In fact, if one could complain at all it would be that some of the old barns are almost too well kept up for the nostalgia-minded artist. But who's going to argue when suddenly you find yourself confronted with an interesting red barn in a friendly setting on a bright sunny summer day.

This farm in southern Michigan has been the inspiration for several paintings and etchings I've done. In winter, in below freezing temperatures, I've walked on its ponds to get material for snow-covered winter trees and snowbanks along the water's edge. In summer I've tried to capture the ever-changing reflections in its ponds. In this painting I'm interested primarily in capturing a memory of the farm itself as a setting for the red barn that is its focal point.

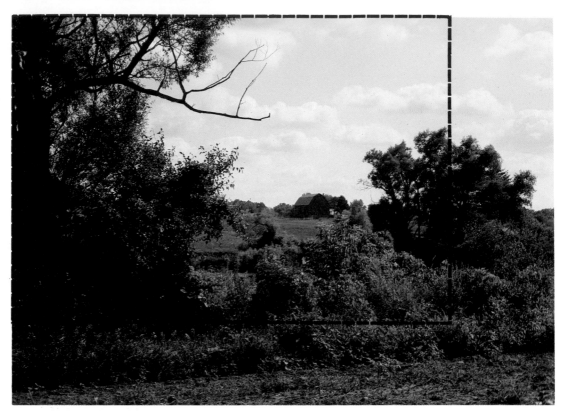

THE LOCATION

Photos taken on location are seldom (if ever) suitable without changes for a fine painting. Some time must be spent simplifying and rearranging the subject matter into a pleasing and unified composition, concentrating on one main center of interest. All other elements of the picture should support this center of interest and help guide the viewer's eye to it.

THE COMPOSITION

I start by narrowing down to just a portion of the scene, omitting much of the confusing foreground and simplifying the large tree. I try cropping the scene from all four sides until I'm satisfied that the final composition is the one that pleases me most.

CENTER OF INTEREST

The red barn becomes the main focal point and is located using the simplified golden mean, (where the diagonal between two corners meets a perpendicular line to a third corner). The trees on both sides help to frame the center of interest and also serve to keep the viewer's eye within the picture area. If the viewer's eye travels to the tree on the left, it is soon redirected toward the barn by the bare limb.

STAGE 1—SKETCH

The bold lines show how the center of interest is located. Sketch is in pencil.

STAGE 2—UNDERPAINTING

Once the composition is established, I do the underpainting in Raw Umber and turpentine. The joy of adding all that color comes next.

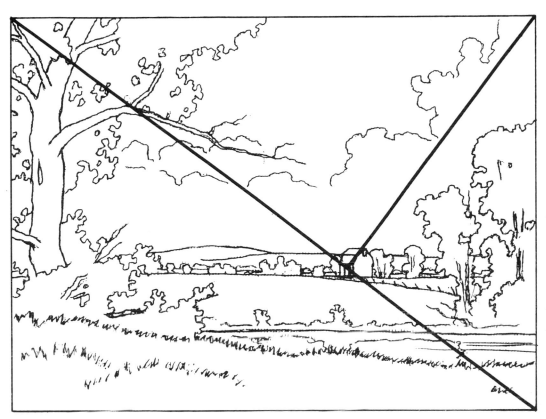

STAGE 1—LOCATING CENTER OF INTEREST, PENCIL SKETCH

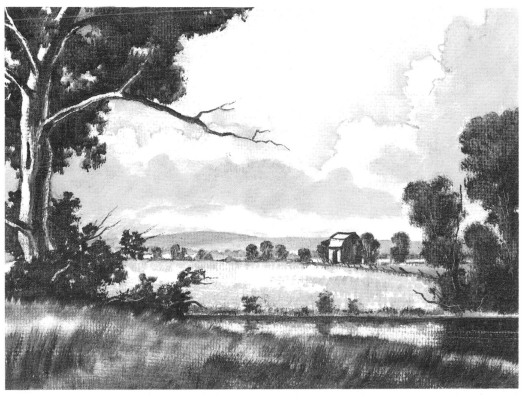

STAGE 2—UNDERPAINTING

29

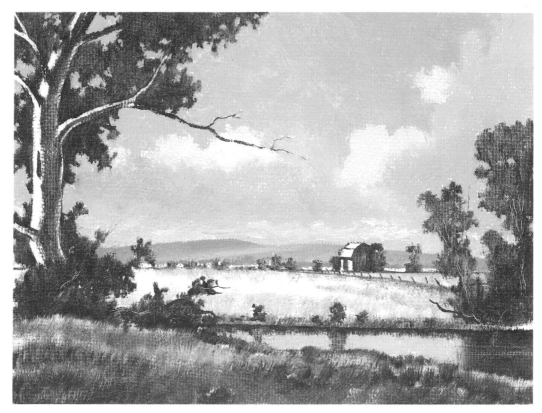

STAGE 3—SKY AND FAR HILLS

I start with the blue of the sky which is Ultramarine Blue, Ochre and White. The sunlit clouds are simply Ochre and White. The darker clouds are Ultramarine Blue, Ochre, Red Light and White. My intention is to make the sky interesting and colorful, but not too dark.

Next, I cover the background hills with the same basic mixture as the darker clouds, but make it a bit darker in tone. To model the hills I lay over this base color some lighter tones of Sap Green, Ochre and White and some of Crimson, Ochre and White. I try to make the brightest accents on the sunny side of the hills and leave the side away from the sun darker.

The far trees are next. I take the same color as used for the darkest clouds and background hills and add a little Raw Umber to it to make the trees a little deeper in tone. The far field is painted with Sap Green, Naples Yellow and White. I may add a touch of Raw Umber to it so it won't be too bright.

Up to this point all the colors used have been soft pastel tones. There are no deep tones or rich colors. It isn't until we get into the middleground that we begin to see brighter and richer colors. Then in the foreground we begin to use the richest and deepest tones and brightest highlights. This gives us the illusion of depth in the painting. And depth is one of the greatest ingredients an artist can put into his work.

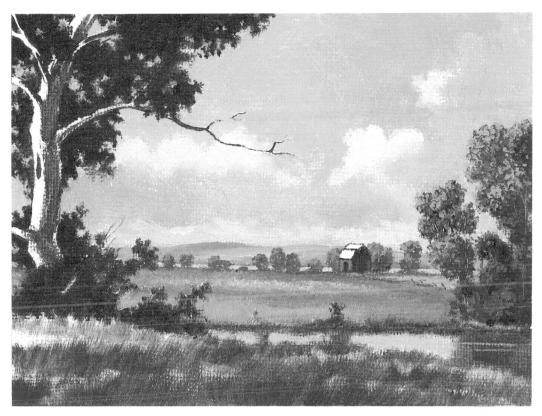

STAGE 4 MIDDLEGROUND TREES & FIELDS

The middleground trees and fields are next and are covered in detail on page 32. The technique for painting the barn is shown on page 33.

The closer trees on the right are then underpainted with their darkest tones of Sap Green, Cadmium Red Light and a little Cobalt Blue. The midtones are Sap Green, Burnt Sienna and White. The lights are Sap Green, Naples Yellow and White. I left part of these trees unfinished to show the progression from dark to light.

The pond merely reflects the colors above it from the trees and sky. I paint in the reflected colors with vertical strokes and then soften with a soft clean brush by using both vertical and horizontal strokes. Some horizontal wind ripples add the finishing touches.

STAGE 5—FOREGROUND & FINISHING TOUCHES

The darks of the close tree on the left are Sap Green and Cadmium Red Light. Portions of foliage toward the light are then painted with midtones of Sap Green, Ochre, Crimson and White. Last come the lightest tones of Sap Green, Naples Yellow, Crimson and White. The colors and technique for doing the tree trunk were covered on page 19.

The close grass and weeds are the last to be painted using darks of Burnt Umber and Sap Green, midtones of Sap Green, Ochre, Burnt Sienna and White, and lights of Sap Green, Ochre and White.

31

PAINTING FAR HILLS...

STEP 1—Hills are first painted with mixture of Ultra. Blue, Ochre, Red Light and White.

STEP 2—Hills are then modeled with lighter tones of Sap Green, Ochre and White, and some of Crimson, Ochre and White.

GOLDEN FIELDS: Short vertical strokes of Naples Yellow, Burnt Sienna and White plus some darker accents of Burnt Sienna and Naples Yellow.

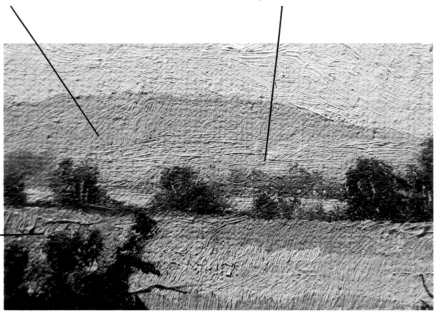

and MIDDLEGROUND TREES:

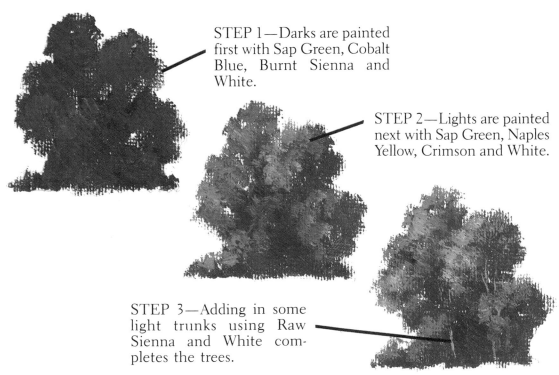

STEP 1—Darks are painted first with Sap Green, Cobalt Blue, Burnt Sienna and White.

STEP 2—Lights are painted next with Sap Green, Naples Yellow, Crimson and White.

STEP 3—Adding in some light trunks using Raw Sienna and White completes the trees.

PAINTING THE BARN...

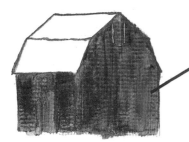

STEP 1—Underpaint siding with Cobalt Blue and Raw Umber using small flat bristle or bright sable.

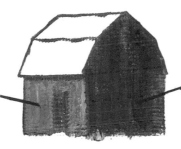

STEP 2—Overpaint sunlit side with Cadmium Red Lt., Raw Sienna and White.

Using small round sable, overpaint shaded side with Cadmium Red Lt., Raw Sienna and Cobalt Blue.

STEP 3—Paint roof with Sap Green, Burnt Sienna and White. Make lower roof a little darker because of its different angle to the sun.

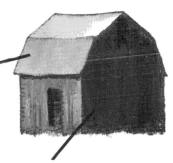

A few vertical strokes of different values give the look of barn siding.

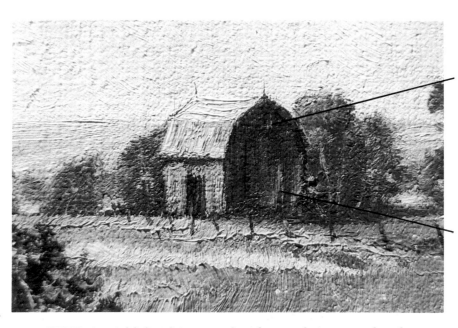

Cobalt Blue and Burnt Umber make deeper darks for openings.

Warm midtones of Raw Sienna and Cadmium Red Lt. indicate warm reflected light from the ground on the shaded side.

STEP 4—Add finishing touches last to bring out details. A few well placed dark and light accents can make a world of difference.

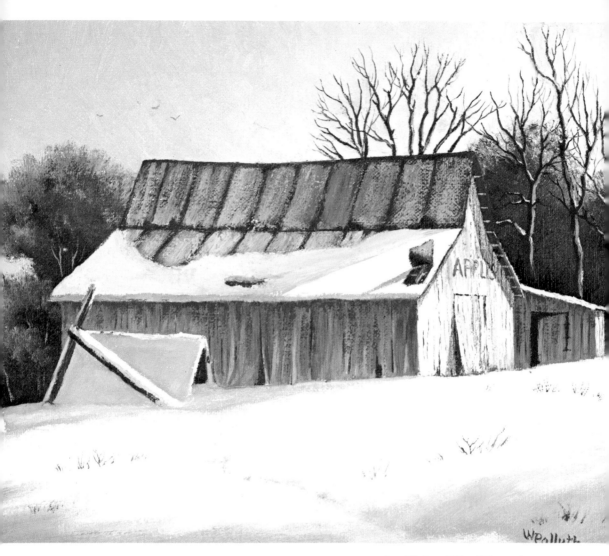

8×10 in. (20×25 cm.)

BAUMANN BARN: Demonstration

This barn is a mile high in the mountains near Yucaipa, California where there are hundreds of acres of apple orchards. It's only five minutes from my studio. The broken down outbuilding and small opening in the door add a little extra interest. The path through the snow helps lead the eye into the scene.

STAGE 1—After making sure of my composition, I sketch on the canvas in pencil or with a brush and Raw Umber and turpentine.

STAGE 2—The underpainting or value wash is also done thinly in Raw Umber and turpentine. At this point I check again to see if anything else is needed to make an effective composition.

34

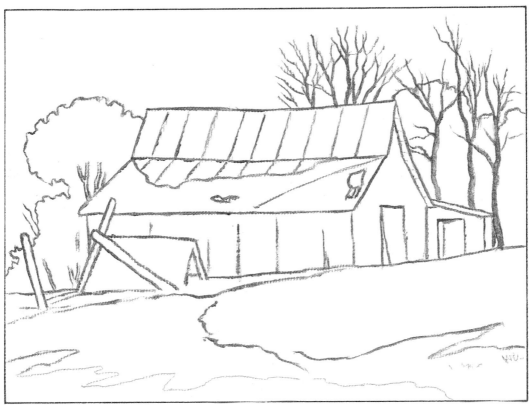

STAGE 1—SKETCH

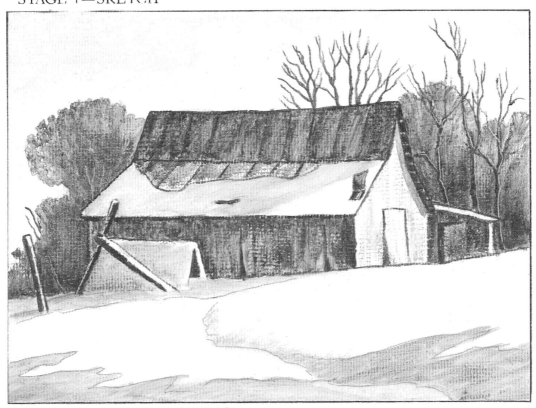

STAGE 2—UNDERPAINTING 35

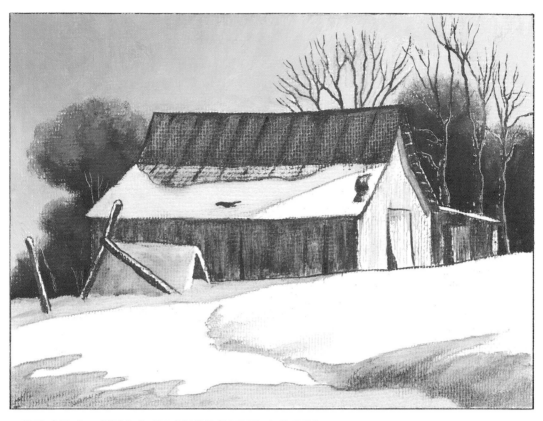

STAGE 3—SKY & BACKGROUND TREES

I start by mixing a graded pool of colors to draw from as I paint in the sky. The deep blue of the sky is a mixture of Cobalt Blue, Ochre, a little Crimson and White. The lighter blue is Cerulean Blue, Yellow Deep, Crimson and White. The lightest tone is Yellow Deep, Crimson and White. The light source is off to the right so I try to make the sky gradually brighter toward the right side of the painting.

I start the background trees next with a basic dark mixture of Burnt Sienna and a little Ivory Black. The lighter tones toward the sun are Burnt Sienna, Yellow Deep and White.

Every art teacher seems to have a different opinion on the use of black, but when I studied the restoration of old master paintings I noticed that many of the old masters mixed black in with other colors to get the effects they wanted. So why can't you and I? The important thing is to get rich clean colors and not to let them get intermixed and dirty. Keep your palette and brushes clean and use thicker paint in your bright colors and you shouldn't have any trouble.

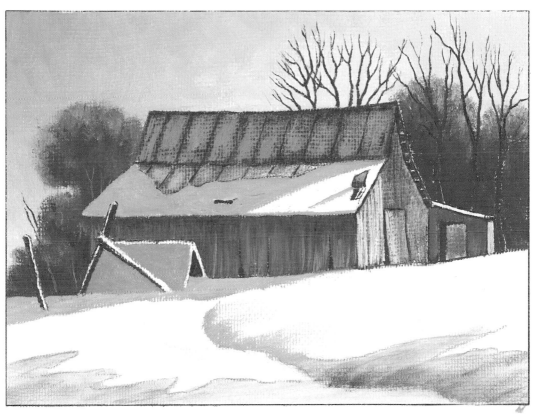

STAGE 4—THE BARN

The new subject matter introduced in this painting is the barn, which is close enough to require some detail in order to satisfy the curious eye of the viewer. The things that stand out are the weathered barn siding, the rust on the roof, and openings in the doorways and siding. These should be brought out in the painting in order to make the barn look real and believable to the viewer.

Some new techniques used in this painting are SCUMBLING and GLAZING. These are explained in detail on pages 38 and 39, showing how the barn siding is done.

The barn roof is underpainted with Burnt Sienna and Ultramarine Blue and then overpainted with some lights of Cobalt Blue, Raw Sienna, Crimson and White. Note how the values change on the roof as its angle to the sky changes.

STAGE 5—SNOW & FINISHING TOUCHES

The snow shadows are painted first using mixtures of Cobalt Blue, Raw Umber, Crimson and White. The sunlit snow is mainly White plus a little Cadmium Yellow Deep. Variations of Yellow Deep, Red Light and White and some of Cerulean Blue and White add interest and viewing pleasure. The weeds pushing through the snow are Raw Sienna and Burnt Sienna.

SCUMBLING and GLAZING for RICHER COLORS

STEP 1—Lay cool dark undertone of Raw Umber and Cobalt Blue. Paint darks thinly.

STEP 2—Scumble over undertone with thicker paint and flat of brush using bright warm tones.

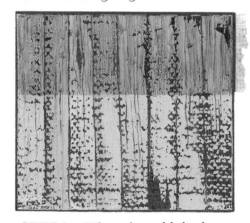

STEP 3—When dry, add shadows with glaze of Cobalt Blue, Raw Umber, Crimson and Copal Painting Medium. Details can be added before or after glazing.

SCUMBLING is merely laying a thick light layer of paint over a darker undertone. If you use the flat side of a fully loaded brush and a very light touch, it can be done over a paint layer that's still wet. This is an example of how you might do the siding of an old barn. Notice how the warm colors stand out against the cool undertones.

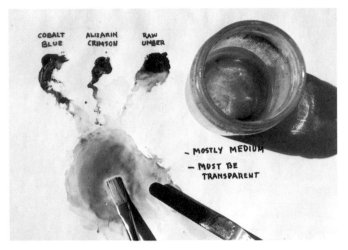

MIXING A GLAZE

GLAZING is laying a darker transparent color over a lighter underpainting. The details and colors of the underpainting still show through. It's perfect for cast shadows on buildings and roads. Transparent shadows are luminous and alive. Notice how details show through glaze.

The underpainting must be completely dry before the glaze can be applied. Mix the glaze using plenty of Copal Painting Medium or any Glazing Medium and very little oil paint. The mixture must look transparent on the palette. Apply it with a soft brush. If it's too light, use more pigment or add another layer. If too dark, wipe out with a rag and turpentine and try again using more medium.

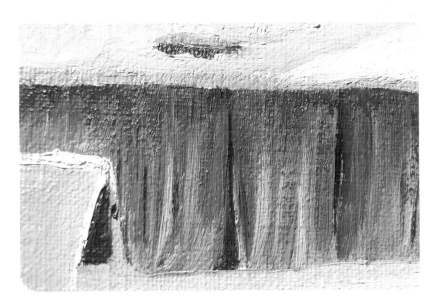

The shaded side of the barn is first underpainted with Raw Umber and Cobalt Blue. I then scumble over the dark underpainting with lighter tones of Cobalt Blue, Ochre, Crimson and White. The reflected lights from the snow are warmer tones of Raw Sienna, Crimson and White. These are brushed from the ground up, gradually disappearing.

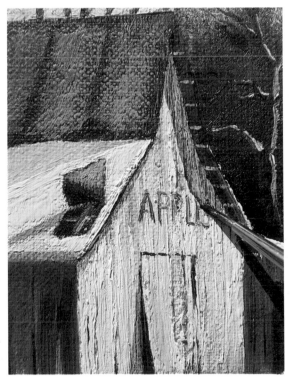

The lighter side of the barn is also underpainted with Raw Umber and Cobalt Blue. Then I scumble over this with warmer and brighter tones of White, Yellow Deep, and Crimson, sometimes adding Blue or Green.

After the light side is dry, I add the cast shadows with a glaze of Cobalt Blue, Crimson and Raw Umber. Subtle details can be added either before or after the glaze. Small accents often make the picture.

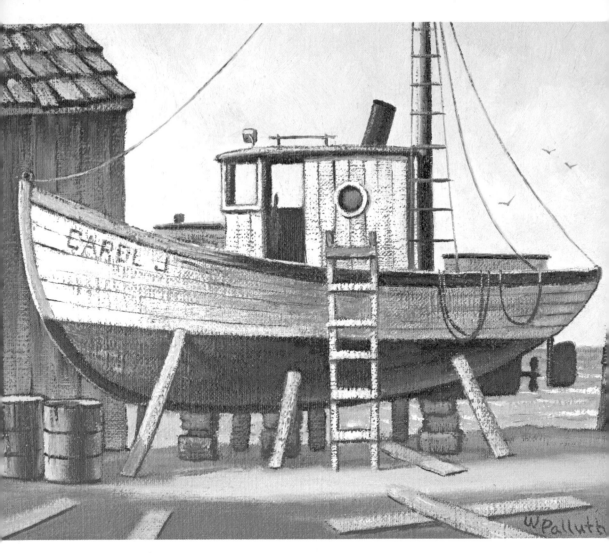

8×10 in. (20×25 cm.)

PUDGY: Demonstration

Boats of all kinds have always fascinated me. I especially love to paint the old sailing ships and fishing boats that have such stories to tell, and I spend considerable time each year visiting old ships that have been restored or preserved such as those at Mystic Seaport in Connecticut.

I found this boatyard scene at Coos Bay, Oregon, during a trip down the West Coast. There wasn't enough time to stay and sketch, so I had to resort to my trusty 35 mm. camera that always accompanies me in my travels. This time I have to be content with painting from a photo.

However, in the resulting photo there's too much material for one painting. Several compositions could be made from this one scene. It's best to leave in just enough to tell the story or make a suitable setting for the center of interest. In this way I'm creating an original scene of my own, putting something of myself into it. To the final composition I become what an editor is to a news story.

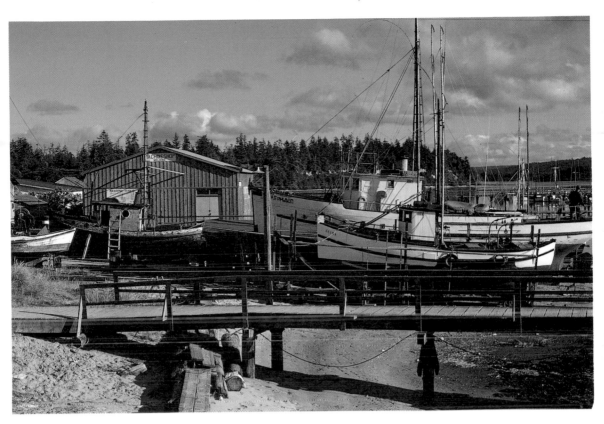

In this photo, there's too much material for one painting.

On location, one way to help in deciding picture content is to use a viewfinder such as this, which is simply a piece of cardboard with a rectangular hole in it to frame the scene I'm looking at and isolate it from its surroundings. A good size for a viewfinder is 5×7 inches with a 3×4 inch rectangular hole. I can look through the viewfinder, moving it around to include different portions of the scene and to check different viewpoints until I select the most interesting view to paint.

The viewfinder of a camera can serve the same purpose beautifully. One big advantage of the camera is that with a zoom lens I can crop or enlarge the scene at will without climbing fences or fording streams. Another advantage is that whenever I see a really interesting or pleasing picture, I can record it permanently on film to use later to jog my memory for color and detail.

I finally narrowed my interest down to the pudgy little fishing boat on the left. It had a story to tell all by itself.

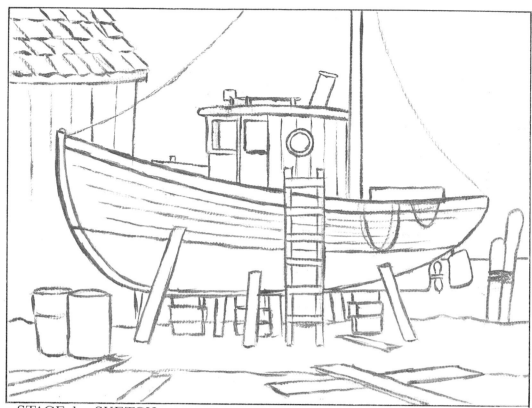

STAGE 1—SKETCH

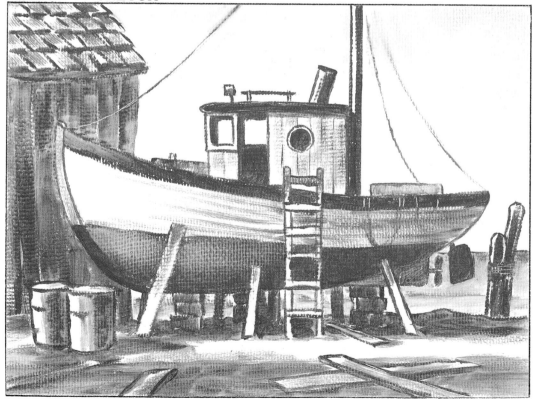

STAGE 2—UNDERPAINTING

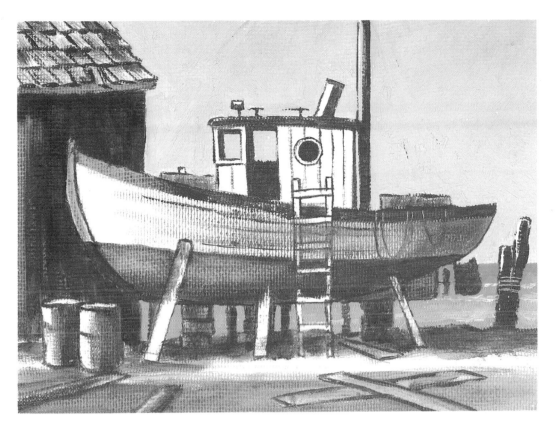

STAGE 3 SKY & WATER

STAGE 1—SKETCH

I begin with the usual sketch in Raw Umber and turpentine, making some changes to simplify and strengthen the composition. I'm interested in the boat but not in the fairly modern building behind it. So I change the building to an old wooden fishing shack.

STAGE 2—UNDERPAINTING

I lay in the value wash with Raw Umber and turpentine, watching for chances to bring out the main masses by using lights in front of darks and darks in front of lights.

STAGE 3—SKY & WATER

I start with the sky, again making it brighter toward the source of light. The blue is Ultra. Blue, Red Light, Ochre and White. The brightest sky is Yellow Deep, Red Light and White. The water is Ultra. Blue, Yellow Light, Red Light and White. The foam is just Ochre and White. I also begin to lay in the dark underpainting of the fishing shack with Ultra. Blue and Raw Umber. I'm gradually working my way up to the boat, which is the main subject.

PAINTING THE WEATHERED BOAT...

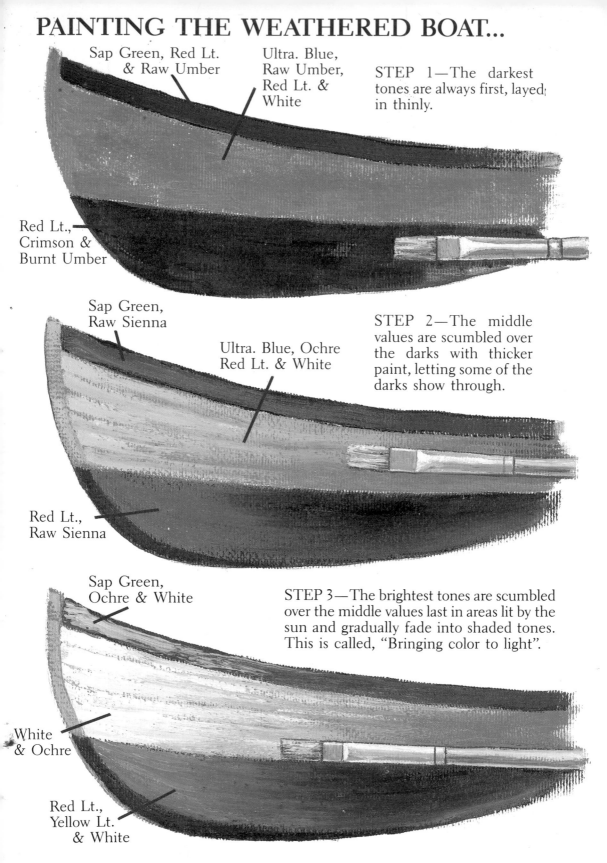

Sap Green, Red Lt. & Raw Umber

Ultra. Blue, Raw Umber, Red Lt. & White

STEP 1—The darkest tones are always first, layed in thinly.

Red Lt., Crimson & Burnt Umber

Sap Green, Raw Sienna

Ultra. Blue, Ochre Red Lt. & White

STEP 2—The middle values are scumbled over the darks with thicker paint, letting some of the darks show through.

Red Lt., Raw Sienna

Sap Green, Ochre & White

STEP 3—The brightest tones are scumbled over the middle values last in areas lit by the sun and gradually fade into shaded tones. This is called, "Bringing color to light".

White & Ochre

Red Lt., Yellow Lt. & White

44

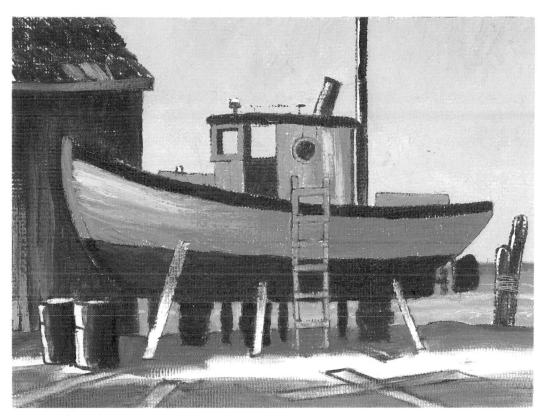

STAGE 4—FISHING SHACK & BOAT

I continue working on the fishing shack by scumbling over the dark under-painting with midtones of Ultra. Blue, Crimson, Ochre and White. I use vertical strokes of varying mixtures and try to let some darks show through in spots. For the roof shingles I overpaint some with Sap Green and Ochre and some with Ochre, Red Light and White. The finishing touch is some darks of Ultra. Blue and Burnt Umber to bring out the shingles.

The technique I follow on the boat is covered in detail on the facing page, always working from dark to light. The mast is Burnt Umber in the darks and Burnt Sienna and White in the lights. The colors for the cabin are similar to those shown for the hull. If the colors don't come out bright enough I just clean the brush and lay on another layer of thick bright paint right over it.

STAGE 5—FOREGROUND & FINISHING TOUCHES

The shaded ground is Ultra. Blue, Ochre, Crimson and White. The sunlit ground is Ochre, Burnt Sienna and White. The darks of the barrels are Burnt Sienna and Ultra. Blue. The midtones are Burnt Sienna, Naples Yellow and White. The lights are just Naples Yellow and White. Don't forget a few seagulls to add atmosphere and life to the painting.

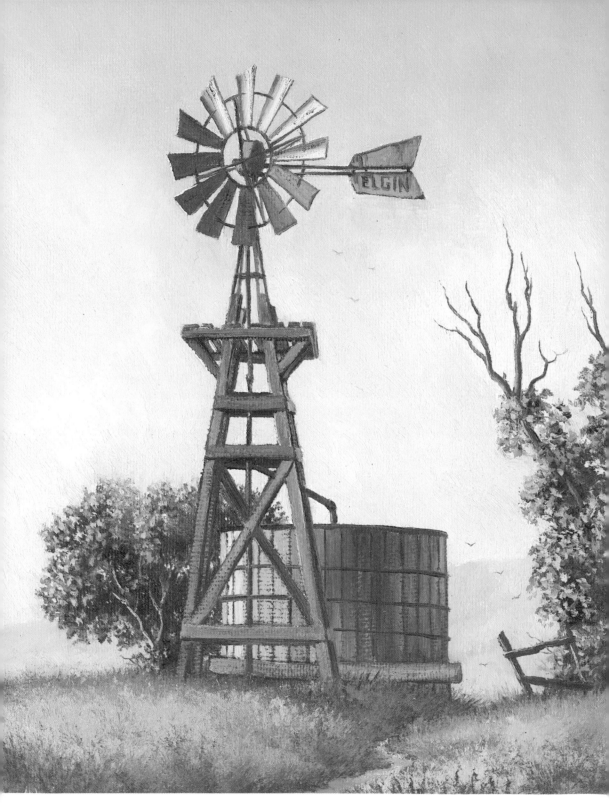

OLD TIMER

9¼ × 12 in. (23.5 × 30.5 cm.)

No matter where you go, water is essential for survival. In the West, many of these rugged sentinels are still in use and stand as a silent tribute to man's ingenuity for adapting to his surroundings.

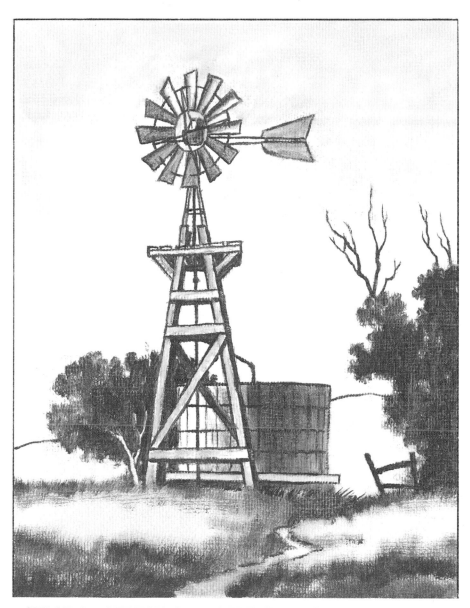

STAGE 1—SKETCH & UNDERPAINTING

For this painting I've combined the sketch and the underpainting into one stage and made it larger so that you can easily see the details of the windmill. The composition is based on the steelyard principle, in which a large mass near the center of the picture is balanced by a smaller mass on the opposite side and further from the center, (similar to the see-saw of childhood days). The viewer can mentally walk up the path into the picture past the center of interest just as a person might walk into the real scene. The tree on the right keeps the viewer from wandering out of the picture too soon.

Notice how often light is placed in front of dark and dark in front of light in order to make things stand out. To make them more visible, the sky is even a little darker behind the sunlit vanes and lighter behind the darker vanes.

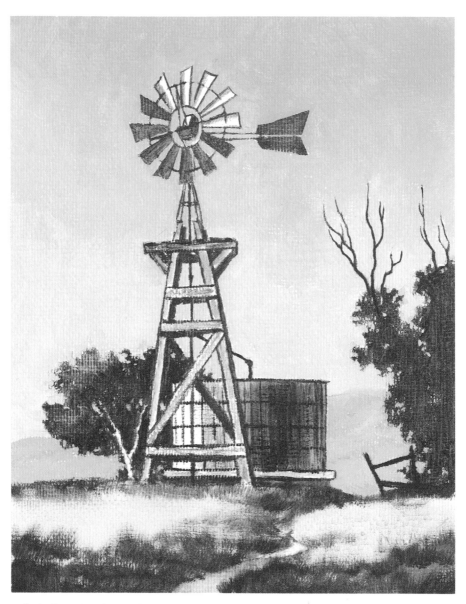

STAGE 2—SKY & FAR HILLS

I start by painting the upper sky with a mixture of Ultra. Blue, Cadmium Yellow Lt., Cadmium Red Lt. and White. As I work down toward the horizon the mixture becomes just Yellow, Red and White. I make the sky a little brighter toward the left in the direction of the light source.

The basic color for the far hills is the same as the upper sky but with a little more Red in the mixture to give it a lavender hue. Over this base color I put some lighter accents of Pink and Light Green. The Pink is Yellow Light, Red Light and White. The Green is Ultra. Blue, Yellow Light and White. Note that all colors so far are pastel, no rich colors or dark tones. As I get closer I use richer colors and darker tones. This helps to give me an illusion of depth, or aerial perspective.

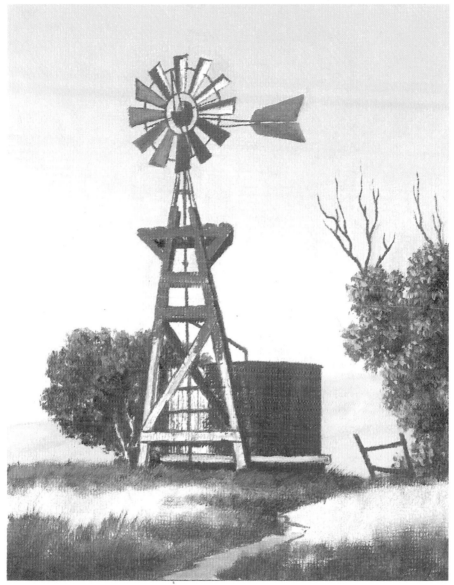

STAGE 3—TREES & WINDMILL

After the sky I work on the trees, starting with Sap Green, Raw Umber and Cadmium Red Light in the darks. The midtones and lights are mixtures of Sap Green, Naples Yellow, Crimson and White.

Starting with the darkest tones the windmill and watertank are next. These are shown here only partially completed. Detailed instructions for the windmill and watertank are shown on the following two pages.

STAGE 4—FOREGROUND

The foreground grass is last. The darks of the grass are Sap Green, Raw Umber and Crimson. The midtones are Sap Green, Naples Yellow, Crimson and White. The lights are Naples Yellow, Crimson and White. Color harmony is enhanced by using similar color mixtures in the lights of the sky, trees and grass.

49

WINDMILL DETAILS

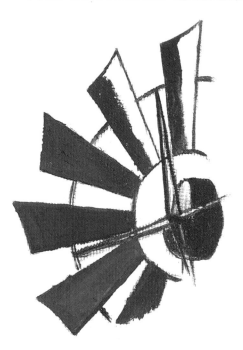

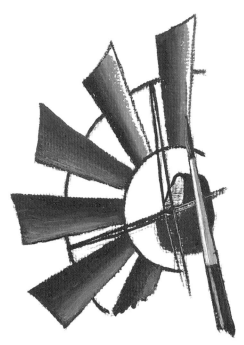

STEP 1—DARKS: Dark undertones of vanes and motor are Ultra. Blue, Burnt Sienna and very little White.

STEP 2—MIDTONES: The midtones on the vanes and the side of the motor are the same mixture with more White.

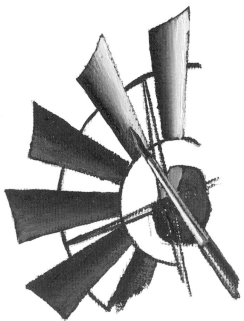

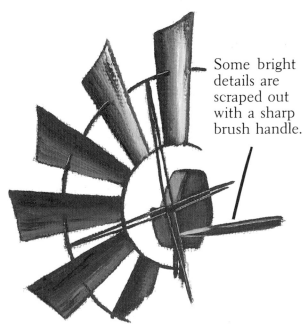

Some bright details are scraped out with a sharp brush handle.

STEP 3—LIGHTS: The lights on the vanes are Yellow Light, Red Light and White. The light on the motor is Burnt Sienna, Yellow and White.

STEP 4—FINISHING TOUCHES: Details are painted last, and light and dark accents are added to make things stand out. Some Burnt Sienna rust helps to accentuate the sunlit vanes.

PAINTING the WATERTANK...

STEP 1—DARKS: The dark underpainting of the wood is Ultra. Blue, Burnt Sienna and in places some White added. But cheer up. This is when it looks the worst.

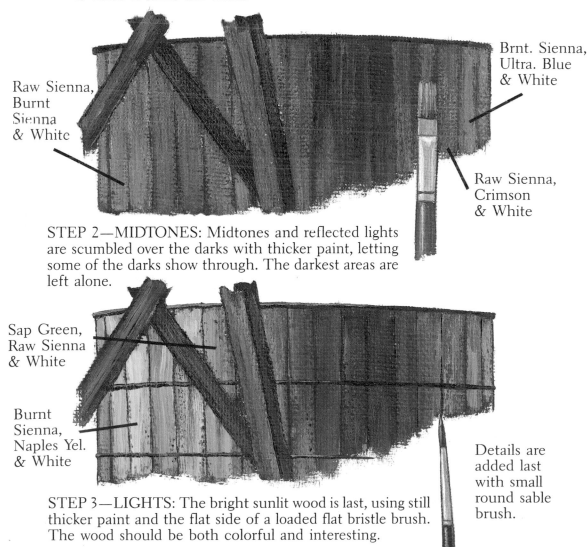

Brnt. Sienna, Ultra. Blue & White

Raw Sienna, Burnt Sienna & White

Raw Sienna, Crimson & White

STEP 2—MIDTONES: Midtones and reflected lights are scumbled over the darks with thicker paint, letting some of the darks show through. The darkest areas are left alone.

Sap Green, Raw Sienna & White

Burnt Sienna, Naples Yel. & White

Details are added last with small round sable brush.

STEP 3—LIGHTS: The bright sunlit wood is last, using still thicker paint and the flat side of a loaded flat bristle brush. The wood should be both colorful and interesting.

TRY A MINIATURE LANDSCAPE...
Just for fun

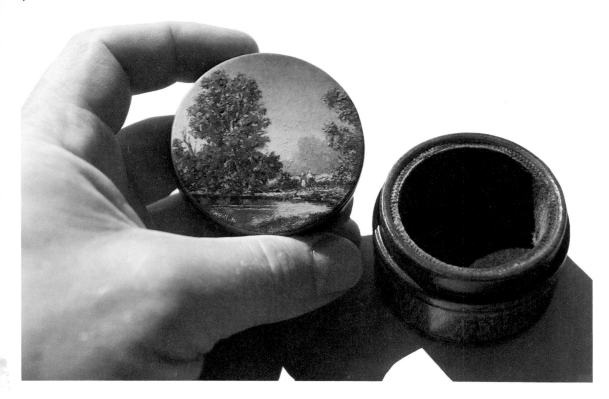

Sometimes a change of pace is good for the soul. For just such a change I love to do miniature oils. I did this painting on a small wooden box that I bought in a craft store. The painting is only 2⅛ inches (5.5 cm.) in diameter.

PREPARING THE BOX:

These boxes usually come unfinished. The surface to be painted is first coated with two coats of Gesso, sanded between coats. On the rest of the box I use two coats of stain and then two coats of polyurethane varnish, again sanding between coats. The inside is lined with olive green velvet to give it that luxurious look. Now it's ready for the painting, to make it a one-of-a-kind keepsake.

COMPOSITION:

The large tree mass on the left is balanced primarily by the two colorful figures on the right. The eye enters the picture at the bottom, follows the edge of the pond, travels past the figures and goes out through the top. I've made most of the edge of the picture darker in value to compensate for the fact that there will be no frame.

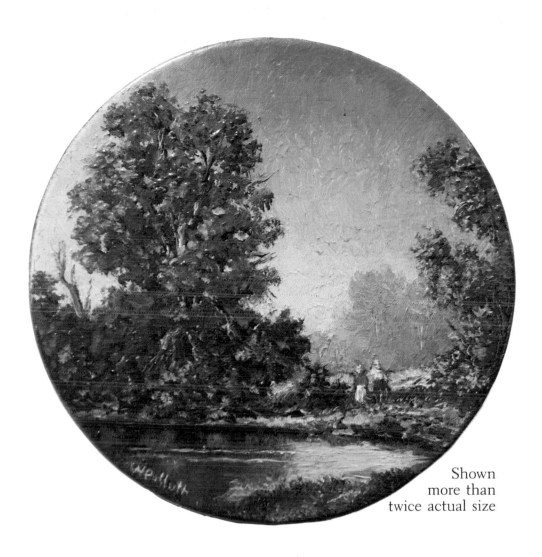

Shown
more than
twice actual size

The painting of miniatures is especially enjoyable for me because I can paint in a looser style than I can when doing larger scenes. I use small sable brushes and may even use a large 2½ power magnifier while painting. Yet the end result is a much looser and more impressionistic style.

A miniature is not the same as a sketch. A sketch implies something that is done quickly, just to get an impression of a mood or effect to paint from later. But a miniature is much more than a quick impression; it's a finished work of art. I often spend as much time planning and composing a miniature as I would for any other size painting. The chief difference in time between painting a very large painting and a miniature, is the time taken to fill more area with paint. For this reason I often wonder why a good miniature doesn't sell for almost the same price as a medium size painting by the same artist.

Yes, even my miniatures start with a pencil sketch. You may start with a brush if you like, but don't allow yourself to be sloppy with the shape of the trees just because it's a miniature painting. The trees still have to be both convincing and interesting. You'd be surprised how many people will want to look at your miniatures through a good magnifier.

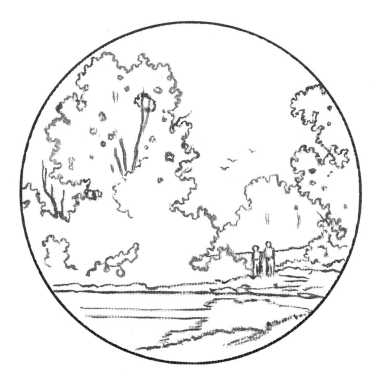

STAGE 1—SKETCH

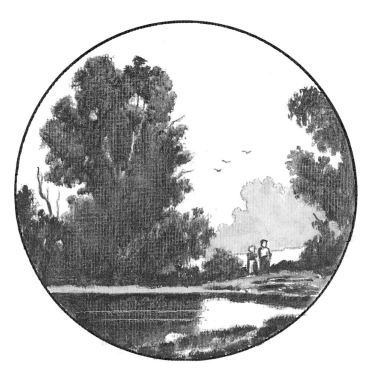

STAGE 2—VALUE WASH

I only try to approximate the values I'd like to see in the finished work without worrying about color. Then when I start to apply color, I only have to try to match the values I've already established and maybe adjust some values a little to help tie the picture together better.

I don't try to get much detail in the small figures, just an overall shape that looks natural and not too stiff. Try sketching small figures from the TV screen for practice.

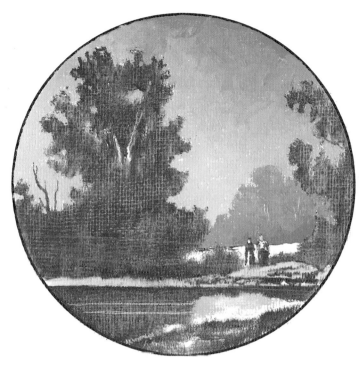

Again I start with the sky and work my way down and forward. The dark sky colors at the top are Cobalt Blue, Raw Umber, Crimson and White. The lighter colors toward the sun and the horizon are Cobalt Blue, Cad. Yellow Deep, Crimson and White. To make painting it easier, I make up a graded pool of colors from dark to light for the sky. The basic mixture for the far trees is the same as for the darkest sky. This stage shows the far trees before the lighter tones are added. The tree trunks are scraped in with a sharpened end of a brush handle.

STAGE 3—SKY & FAR TREES

The darks of the trees are first, using Cobalt Blue, Raw Sienna and Crimson. The midtones are next with Ochre and Crimson, then the lights using White, Yellow Deep and Crimson. I left part of the trees in each stage to show how the midtones and lights give form to the trees. The dark greens are Sap Green and Crimson. The midtones and lights are Sap Green, Crimson, Naples Yellow and White. Using a small bright sable, I carry the tree colors down into the water with vertical strokes. The golden field is Naples Yellow, Crimson and White. I add dark variations of Burnt Sienna and Sap Green for interest.

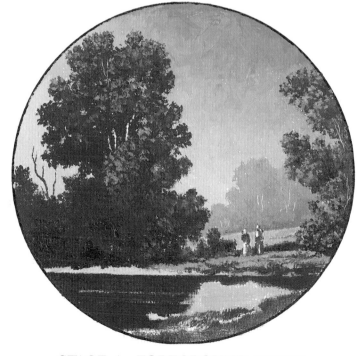

STAGE 4—FOREGROUND TREES

55

FIGURES IN LANDSCAPE PAINTINGS

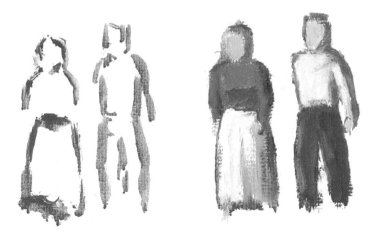

The figures in this miniature landscape are only 3/16ths of an inch high and should need only a few well placed strokes of color to represent them. As you can see, there is no detail, just some colors placed to represent clothing and faces.

The next set of figures could be used in a larger painting. They are still loosely done, but with a little more detail in light and shade and in the overall pose.

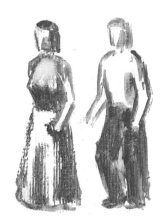

STEP 1—Simple Raw Umber sketch and value wash, just as I do on the rest of the painting.

STEP 2—Placing the darks. The red is Cad. Red Lt., Cobalt Blue and Raw Umber. The dark blue is Cerul. Blue and Raw Umber. The shaded white is White, Cerul. Blue and Raw Umber.

STEP 3—Placing the lights. The light red is Cad. Red Lt., Yellow Deep and White. The light blue is Cer. Blue, Ochre and White. Light white is White and Ochre. I add Red Lt. to this for flesh.

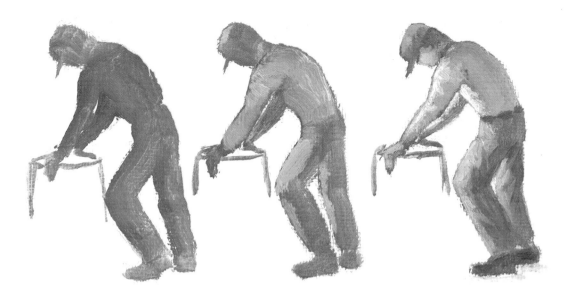

Another method for quickly doing figures is to start with the overall form using just the predominant color, and then just adding the lights and darks to complete the figure. This method is illustrated above and to the left.

Landscape artists should try to compose pictures in which the figure is not predominant, but just a natural part of the landscape, doing something that fits in with the overall location or theme.

You might recognize these characters from my book, "COMPOSITION MADE EASY". They were the focal point of a painting called "Sunday Afternoon".

Figures can be a great asset to a painting, however, the scene must be designed with the figures already in mind. They can seldom be added as an afterthought without destroying the overall balance of the composition.

A small figure can give scale to a scene by adding something of known size for comparison with its surroundings. Figures can also be the focal point, because the use of color or action immediately attracts the viewer's eye. Used properly, they can do a great deal to add life, scale and human interest to your works.

57

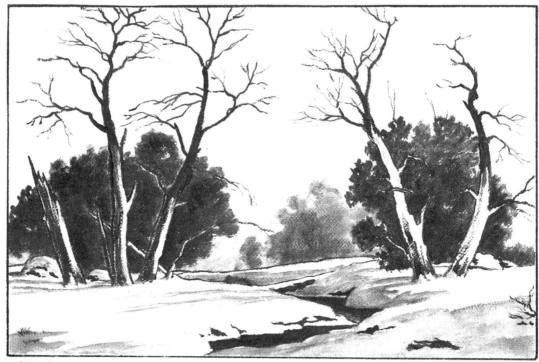

STAGE 1—SKETCH AND VALUE WASH

EARLY SNOW: Demonstration

Sometimes the material that's placed before the artist by the Creator is just too overpowering to place on a small canvas. I painted this restful scene on 24" × 36". It's simple in composition, but quite complex in the trees. So to retain our sanity, we'll simplify and omit some of the smaller tree detail.

STAGE 1—SKETCH & VALUE WASH

I begin with a pencil sketch and a diluted wash of Raw Umber and turpentine. The sky is simple so I don't bother to underpaint it.

STAGE 2—SKY

A color pool is mixed for the sky using Cobalt Blue, Ochre, Crimson and White in the darks toward the zenith (very sparing on the Crimson). As the sky approaches the horizon it becomes a warm golden tone mixed from Cad. Yellow Deep, Cad. Red Light and White. I try not to cover up too much of the tree limbs while painting the sky.

STAGE 3—TREES

The darks of the middleground trees are Sap Green and Burnt Sienna. Lighter greens and reds are varying shades of Sap Green, Burnt Sienna and White. Lightest tones are Sap Green, Yellow Deep and White, and Burnt Sienna, Yellow Deep and White.

The following pages show how to paint the close trees, the stream and the snow. To get a strong feeling of sunlight, I try to get all the colors of the rainbow into the sunlit portions of the snow; pinks and light greens, light warm yellows, even a few light blues.

58

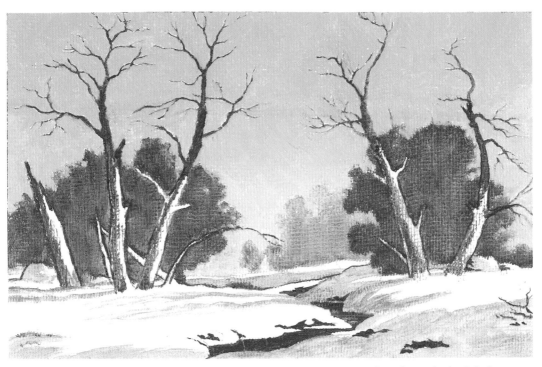

STAGE 2—LAY-IN OF THE SKY: I try not to overmix the sky colors. It's better to leave some of the mixing for the viewer.

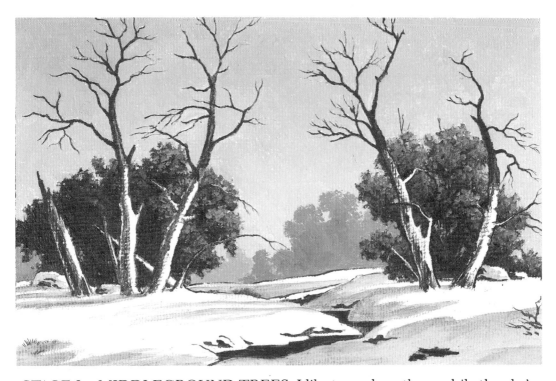

STAGE 3—MIDDLEGROUND TREES: I like to work on these while the sky's still wet so that the edges of the trees can be blended softly into the sky. The trees on the left are still unfinished, showing how they are painted from dark to light.

WINTER TREES....Detail

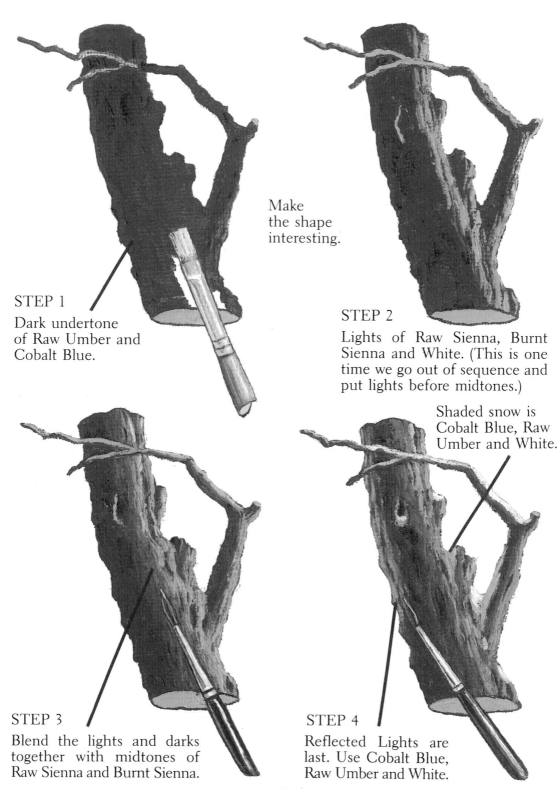

Make
the shape
interesting.

STEP 1
Dark undertone
of Raw Umber and
Cobalt Blue.

STEP 2
Lights of Raw Sienna, Burnt
Sienna and White. (This is one
time we go out of sequence and
put lights before midtones.)

Shaded snow is
Cobalt Blue, Raw
Umber and White.

STEP 3
Blend the lights and darks
together with midtones of
Raw Sienna and Burnt Sienna.

STEP 4
Reflected Lights are
last. Use Cobalt Blue,
Raw Umber and White.

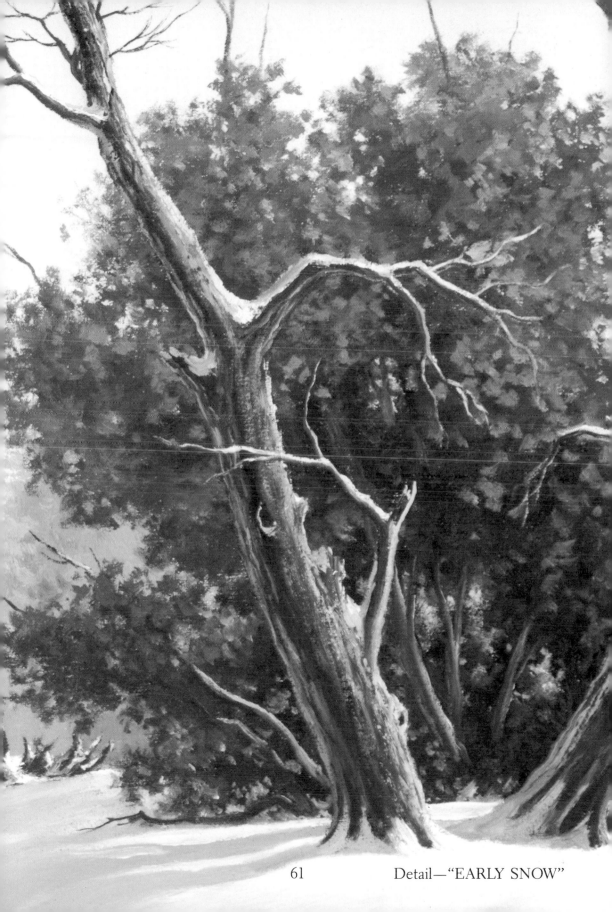

61 Detail—"EARLY SNOW"

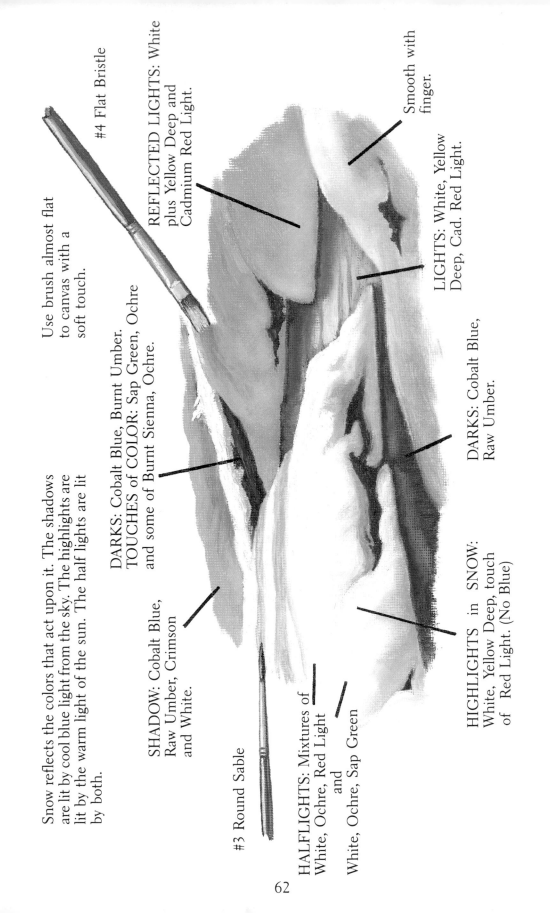

#4 Flat Bristle

Use brush almost flat to canvas with a soft touch.

REFLECTED LIGHTS: White plus Yellow Deep and Cadmium Red Light.

Smooth with finger.

LIGHTS: White, Yellow Deep, Cad. Red Light.

DARKS: Cobalt Blue, Burnt Umber. TOUCHES of COLOR: Sap Green, Ochre and some of Burnt Sienna, Ochre.

DARKS: Cobalt Blue, Raw Umber.

Snow reflects the colors that act upon it. The shadows are lit by cool blue light from the sky. The highlights are lit by the warm light of the sun. The half lights are lit by both.

SHADOW: Cobalt Blue, Raw Umber, Crimson and White.

#3 Round Sable

HALFLIGHTS: Mixtures of White, Ochre, Red Light and White, Ochre, Sap Green

HIGHLIGHTS in SNOW: White, Yellow Deep, touch of Red Light. (No Blue)

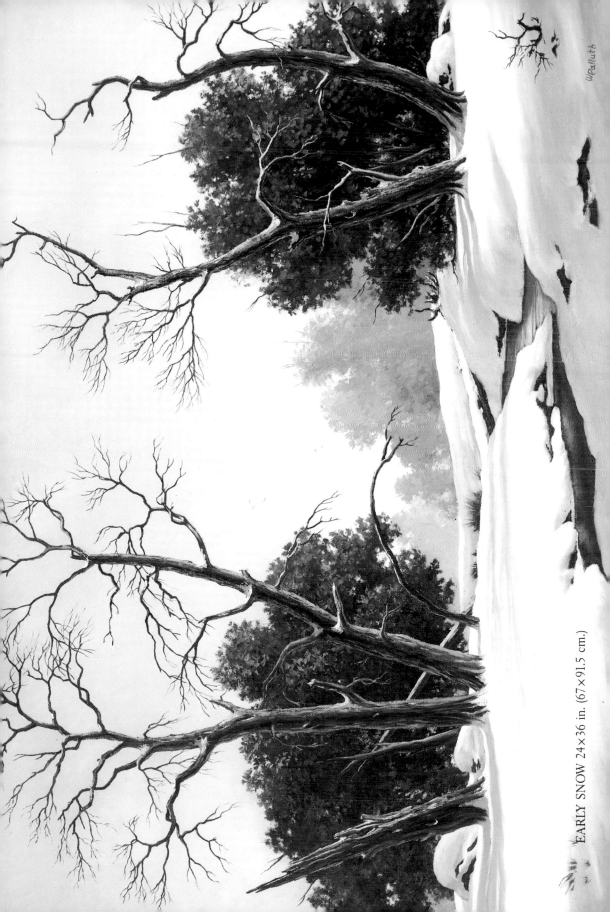

EARLY SNOW 24×36 in. (67×91.5 cm.)

WPalluth

NOW—PUT YOURSELF IN THIS PICTURE!

Dear Reader,

It has been my pleasure to put the techniques I've learned or developed in over a quarter century of painting into pictures and the printed word for you to study and benefit from. Now it's your turn. So get your gear together and start painting! Try doing the paintings in this book, try some on-the-spot sketching, and try composing your own pictures from a combination of on-the-spot sketches and photos. You're sure to have fun...and sure to improve your painting. So how can you possibly lose?

I wish all of you the very best of luck and success in landscape painting.

W. PALLUTH